"A slim but powerful primer on viewership, *At the Lightning* is as enlightening as it is pleasurable to read. Laura Raicovich is in the business of complicating what it means to engage with a work of art, and as she describes her exploration of *The Lightning Field* she draws on the wide-ranging influences that informed her experience, situating the work within a rich matrix of natural, scientific, and cultural activators. Generous and nimbly wrought, *At the Lightning Field* is a model for what rigorous engagement with art should entail."

—KATHARINE SOLHEIM, UNABRIDGED BOOKSTORE

"Laura Raicovich's *At the Lightning Field* is a beautiful and striking meditative essay on art, memory, time, and space. The lines on the page dance and, just as the lightning poles on that plateau in New Mexico do, vary in length in order to create an even plane in both space and mind. The rhythm that this pattern instills in the reader fosters an almost mystical quality in the writing that leaves an indelible impact on the mind. This repetitive pattern will urge you to, no, demand that you devour this essay at once.

She says, '*Permanence:* Begin with permanence (a slippery concept—despite its will to be otherwise—and inextricably tied to time). Permanence makes me look more closely, notice details, large and small, that define moments as they accumulate.'

That is beautiful. This was a truly pleasurable read."

—MATT KELIHER, SUBTEXT BOOKS

At the Lightning Field
Laura Raicovich

COFFEE HOUSE PRESS

Minneapolis

2017

Coffee House Press books are available to the trade through our primary
distributor, Consortium Book Sales & Distribution, cbsd.com or
(800) 283-3572. For personal orders, catalogs, or other information,
write to info@coffeehousepress.org.

Coffee House Press is a nonprofit literary publishing house.
Support from private foundations, corporate giving programs,
government programs, and generous individuals helps make
the publication of our books possible. We gratefully acknowledge
their support in detail in the back of this book.

LIBRARY OF CONGRESS CATALOGING-IN-PUBLICATION DATA

Names: Raicovich, Laura, 1973– author.
Title: At the Lightning Field / Laura Raicovich.
Description: Minneapolis : Coffee House Press, 2017. | Includes biblio-
 graphical references.
Identifiers: LCCN 2016039378 | ISBN 9781566894661 (paperback)
Subjects: LCSH: De Maria, Walter, 1935–2013. Lightning field. | De Maria,
 Walter, 1935–2013—Criticism and interpretation. | Earthworks (Art)—
 New Mexico. | BISAC: ART / Criticism & Theory. | TRAVEL / Special
 Interest / Literary. | NATURE / Essays. | LITERARY COLLECTIONS /
 Essays.
Classification: LCC N6537.D432 A68 2017 | DDC 709.2—DC23
LC record available at https://lccn.loc.gov/2016039378

PRINTED IN THE UNITED STATES OF AMERICA

24 23 22 21 20 19 18 17 1 2 3 4 5 6 7 8

For Giacomo Cender

At the Lightning Field

Walter De Maria's *The Lightning Field* is composed of four hundred stainless steel poles positioned 220 feet apart. The site, in the desert of central New Mexico, was selected for its "flatness, high lightning activity and isolation"[1] and is bounded on the east, west, and south by ridges of distant mountains. The sharply pointed poles demarcate a grid one mile by one kilometer and six meters. The poles:

two inches in diameter,

average height 20.62 feet,

shortest measuring 15.07 feet,

tallest 26.72 feet.

Variations in height accommodate variations in topography. The tips of the rods are calibrated such that they could "evenly support an imaginary sheet of glass."[2]

Walter De Maria completed *The Lightning Field* on October 31, 1977. It is in the collection of Dia Art Foundation, which is charged with its maintenance and protection. I worked at Dia from early 2002 to late 2011, and over this near decade, I visited many times, including in October 2003, July 2004,

June 2006, and July 2008. The artwork confounded me and revealed thoughts about time, space, duration, and light. In this book, I recount my experiences at *The Lightning Field*.

Reconstituting past experience relies on a process of forgetting and transformation that, by chance or design, evolves in the course of remembering. These writings are dedicated to the recall of highly specific, vivid experiences of a work of art.

Visit 1: October 18 and 19, 2003
Visitors to *The Lightning Field* are required to stay overnight at a small cabin just north of the grid of poles.

"I would have stayed longer," I thought.

Four friends joined me on my first visit (the cabin can accommodate six). We arrived via Albuquerque and drove several hours to a small town called Quemado. Quemado is remote, the drive aggressive in its austere beauty. We took the longer route through the El Malpais National Conservation Area. North of the road, rocks jut into the massive sky, and an expanse of desert stretches to the south, topped by ancient black lava flows, out of which grow gnarled piñon trees.

The town seemed improbably empty, dusty, and shuttered when we arrived, and we left the car parked in front of a strand of low adobe buildings. Robert Weathers, *The Lightning Field*'s caretaker since its completion, met us at the visitor's office and drove us to the field.

Robert is not a man to mince words or to use them often. He is tall, slim, and weathered, and Robert's age is difficult to discern. He is a cowboy. He wears a silver belt buckle on his jeans; a prize from his rodeo days. He grazes a herd of cattle on the land surrounding the field. Raised in nearby Pie Town, he often silently listens to Waylon Jennings as he speeds a Suburban on the dirt roads to and from *The Lightning Field.*

We arrived just after midday, the sun at its highest.
Clear sky.
The poles were ephemeral—
barely visible as the sun's midday rays
skimmed down
the vertical shafts.

I thought, "There's not much out there."

The sky was the biggest thing, then the desert.
It was difficult to discern scale and distance.
The horizon could have been ten miles or one thousand miles away.
After the density of the horizonless city,
where sky grazes buildings rather than
kissing the earth,
any distance seemed possible.

We abandoned our gear in the cabin and headed into the
field of poles.
Circumambulation seemed a logical starting point.
We headed west and began to understand what distance
meant.

Moments before, the poles were willowy, evanescent, almost
not there.
Their material, machine-made quality contrasted with the
unruliness of nature's
variations in the landscape.
The low-slung brush was bleached out
sage green,
gray brown;
dull-yellow anthills contributed a variegated
topography (pay attention, don't trip).
Above, quickly moving cumulus clouds.
These were variables, the poles constant.

Close up, the steel poles stretched toward the sky, most over
three times my height, poking sharp tips into the blue above,
knitting dusty earth to sky.

They form a grid.
Four hundred poles arranged orthogonally,
their alignment as precise as their cool, smooth surfaces.

Circumambulating *The Lightning Field*, I walked the perimeter, the edge between the landscape and steel.

As I walked, time distended and contracted as the poles went from rigid regularity to a seemingly haphazard arrangement and back again. Looking into *The Lightning Field*, the farthest poles were toothpicks at an incalculable distance. Poles aligned with their siblings along north–south and east–west axes, then a few steps on disappeared, subsequently expanding into a less regular arrangement, and again forming a pattern:

Tall (close)

Medium (distant)

Medium (more distant)

Short (farthest)

Medium (closer)

Medium (closer)

Tall (closest)

And repeating again, again.

I flattened my vision to see them on the same plane, like a bar graph representing an unknown trend. Steps farther on revealed a jumble, then back to the axial arrangement, ordered and comprehensible.

Entering the field of poles, I encountered the same phenomenon, surrounded. The grid flipped back and forth between regular alignments and seemingly chaotic configurations.

Now the grid clear and simple,
then disorder,
next the pattern of the short and tall poles that defined the
expanse of the grid,
disorder again,
and the grid, and so on.
It was a potentially endless cycle, the possibility of infinity
suggested by the arrangement of the poles, their relationship
to one another, and their environment.

Inside the grid, I could not discern whether the smallest pole
I saw in the distance was the edge of the field, or if I simply
could not read its limit.
From one border,
the other edges of the field were unclear except at the
corners of the grid.
(What are the limits of my vision?)
Even then, only two boundaries could be observed with
certainty.
The implication,
infinity.

I thought about perfect geometries and the incremental,
creeping
expansion of the universe;

the messiness of the cosmos;
the slowing
rotation
of the earth.

Despite our will to regularize time, the earth isn't a sphere;
the orbit around the sun is elliptical; other objects in the
galaxy have an impact on the earth's rotations and orbit,
notably the moon with its own particularities of density,
orbit, and variable gravitational pull.
(Sometimes seconds must be added to the atomic clock to
approximate accuracy.)
The earth wobbles on its axis,
it is slowing down.
It is farther or closer to the sun
depending on the time of year.
At *The Lightning Field,* I thought I felt its motion.

My sense of time in the city meant nothing in this place. It
was replaced by a feeling of forever that was closer to geo-
logic time than my own notions of a day or week passing.
I thought I could understand big things better if I stayed. I
wanted to commit to being in this place—as I said, I would
have stayed longer.

In 1968, art critic David Bourdon wrote (before *The Lightning Field* was built): "De Maria is after a deeper commitment on the part of the spectator, who is asked to become an agent or catalyst in the fulfillment of the work . . . the burden of response is placed not on the sculpture but on the spectator. The degree and quality of spectator engagement becomes crucial."[3]

It is worth noting that while at school at the University of California at Berkeley in the late 1960s De Maria knew La Monte Young, and through this affiliation with Young became familiar with the work of John Cage. Cage's work and its focus on randomness, distension of time, and Eastern philosophies informed De Maria's practice and, in part, inspired a work entitled *Cage* (1961–65).

Variations in desert temperature were significant
from midday to night and back again;
a loud gulp of quiet;
an intense aural experience of silence for lack
of rustling trees or human sounds only broken by occasional
animal noises.
(Could not sleep,
despite being deeply tired.
Even half-awake dreams were impossible.
Too quiet,

no comfort from white noise.
The most solid silence.)
Periodic recalibration of human scale in contrast and conti-
nuity with the poles, sky, and earth was required; anticipation
of possible, but rare, lightning, a constant.

The Lightning Field defines a particular organization of space,
experience, time, and light. The artwork permanent, the
experience variable.

Chaos and coincidences of history
Edward Lorenz was a meteorologist at MIT in the early 1960s.
Looking for a devil in the detail of meteorological data,
he was trying to forecast global weather patterns (creating
forecasting models that would later be applied to economics
and financial analysis).
Complicated sets of equations,
sometimes arbitrary webs of information,
measurements of "initial conditions"
churned through a primitive computer.
The machine was named The Royal McBee.

During one of his sessions in the winter of 1961, Lorenz
found that very small, previously considered
statistically insignificant

variations in the initial
input of data produced extremely diverse and unpredictable
outcomes.
His data mapped butterfly
shapes, showing that cascades of small quirks
in analysis over time produced
wildly different predictions.
The results revealed vast inaccuracies in any long-range
forecast.

Lorenz identified a "sensitive dependence on initial
conditions,"[4]
a dependence that required stability of
initial data without which
the forecast would be unpredictable.
He invented the Lorenz Attractor, a butterfly-shaped diagram,
a series of loops hovering
over a three-dimensional axis.
Each point that made up the curve of the loops represented
data that, over the course of the model's run,
absorbed errors.
(Memories? Inaccuracies?)
The butterfly maps a repeating pattern that, due to small
perturbations within the system,
is aperiodic.

Lorenz's butterflies depict incidents of "chaotic" pattern-ing. The patterns reveal something about scale and the relationship between the very large and very small. He identified these patterns by looking carefully at weather, but they were not new. Ideas of this kind had existed since the nineteenth century; Lorenz's butterfly made others also look more closely at these phenomena.[5]

Stumbling on Lorenz, I thought, "Perhaps it is a coinci-dence of history."

A year before Lorenz examined weather patterns and iden-tified his butterfly-shaped diagrams as indicators of chaos, De Maria wrote "On the Importance of Natural Disasters."

> *I think natural disasters have been looked upon in*
> *the wrong way.*
> *Newspapers always say they are bad. a shame.*
> *I like natural disasters and I think that they may be*
> *the highest form of art possible to experience.*
> *For one thing they are impersonal.*
> *I don't think art can stand up to nature.*
> *Put the best object you know next to the grand*
> *canyon, Niagara falls, the red woods.*
> *The big things always win.*
> *Now just think of a flood, forest fire, tornado,*
> *earthquake, Typhoon, sand storm.*

> *Think of the breaking of the Ice jams. Crunch.*
> *If all of the people who go to museums could just*
> *feel an earthquake.*
> *Not to mention the sky and the ocean.*
> *But it is in the unpredictable disasters that the*
> *highest forms are realized.*
> *They are rare and we should be thankful for them.*[6]

A curve, in the shape of a butterfly, can describe the future as a forecast. This forecast, Lorenz showed, may not be accurate. The curve can also describe the past as accumulations of experience.

I remembered Nabokov, and his butterflies.

January 2006, in New York City
It is hot inside, cold on the other side of the pane.
Dew on the inside surface of the glass,
clouded over.
Despite the cold, the sun is bright outside. The heat comes on again too soon,
and minuscule droplets
multiply, making the surface of the glass seem furry, no longer slick or transparent.
At the top of the glass, where it meets its frame
(centered along this horizontal axis),
a narrow drip begins to crawl south.

It bisects the pane;
a slice of the view outside,
revealed.
A stripe of cerulean, then masonry (the façade of the build-
ing across the street).
A strip of exterior made visible.

A few days later, in a car on the way to the airport
Early. Still dark.
Looking from the inside, it is cold out. Inside it is warm,
and dew
accumulates on the skin of the glass. The dew is not very
dense.
Shadows signal
distant buildings; lights glow.
Tangerine globes are surrounded by halos,
and some, as the damp scrim
grows more substantial, smear into diagonals.
Javelins of light in the dark. They refract across the water,
catching
ripples on the surface, animated in their precision.

I watched these changes in light and made sure to
remember them.
The light shifted.

Sleep, memory

Remembering is a tricky business. The relationship between sleep and time, in somnolent and insomniac states, has a habit of distorting time in analog to the recall of past experience.

I ask myself, "Did that really happen, or was it a dream?"

A Belle and Sebastian lyric stuck in my head: "Judy never felt so good except when she was sleeping." Could have been me. Sleep is a luxury of time, particularly when it is elusive: sleep bends time, quirkily
maps time.
Compression, elongation, déjà vu—like mirroring, repetition, and slow motion are among sleep's arsenal of tricks.

Waking can recall feelings of a too-fast night passed
(like recollection?),
time condensed,
immaterial and disintegrated, or stretched and elongated.
Minutes of sleep can seem eternal.
Sometimes, sweetly aware of sleep, I am conscious without being awake, and knowingly experience its pleasure.
Moments distend into hours.
The duration of mundane activities
stretch

into thin threads that reconstitute and tangle,
accelerating the illusion of time passing,
bringing it back to the present and waking states.

I am grateful for this other side of time.
Alternate to the clock and regularity,
its sister,
the other side of the coin,
another register.

As in most seemingly oppositional relationships, one without the other is less compelling. A visit to *The Lightning Field* offers experiences that illuminate this notion. The less ordered comprehension of time
(unpredictable shifts)
is revealed only in relationship to measured time,
regular intervals, delimited duration, linear movement, sequential experience:
the passing of a day, the path of the sun, the rotating
hands of a clock. Stacked and interleaved, like layers of sedimentary rock, these accumulations of time,
both irregular and calculable,
are carriers of experience.

The recall of these experiences adds an extra kink.
Memory reconstitutes

primary experience.
Select details are subtracted,
amplifying others,
adding emphasis where none existed before,
conflating distinct moments into one.
Unreliable.

As the years have passed since the visits to the field recorded here, my memories slur. I have vivid images of the perfect white and yellow desert flowers twittering in the wind, the glassy, bold eye of a jackrabbit sizing me up, the uncanny states of sleeplessness at high altitude, and the pattern/nonpattern of a grid of steel in a desert. And yet, I may have simply constructed these quite believable memories from rewriting my notes iteratively. How reliable am I? Are the images only in my mind?

In the process of recalling *The Lightning Field*, I locate
intersections of memory and external associations, effects
they promote
and thoughts they evoke. They describe an arc of experience.
As these phenomena
agglomerate, time skids and solidifies
at once, embedding an unruly set of parallelisms into the
resulting text.

Permanence

Begin with permanence (a slippery concept—despite its will to be otherwise—and inextricably tied to time). Permanence makes me look more closely, notice details, take note, and absorb changes, large and small, that define moments as they accumulate.

Units of time,
experience,
accretions.

A narrative reconstruction of a memory relates only bits and pieces of a more complex experience. The rest is left out, not remembered. Permanence can hold together series of these bits and pieces.

Calculus

In high school, I didn't like math class. Nonetheless, I took calculus, and fell in love with a set of ideas. The shape of a curve could describe

a day,
an hour,
a minute,
a second.

The curve is defined by an accrual of points, which, when added together, describe a whole. While the idea had great appeal, executing the calculations required was of little

interest. I tried to get out of the course. My mom and I met with my guidance counselor. As we sat to discuss the course, Mr. Satriano (or was it Santelli?) arrived. He was nice, a man who taught high school math seriously and wore orthopedic shoes. When he walked around the classroom, I could never hear his footfall. We talked about me dropping the course. He cried, so I stayed, muddling through.

Like Lorenz's butterfly, calculus can provide a method to visualize the process of remembering: to take a moment and break it down, dismantle time, locate the points
that accumulate to create a curve, a series of memories.
The vocabulary of the discipline alludes to a lyric narrative:
sine,

cosine,

tangent.
Each moment remembered constitutes a point on the curve. The voids between points map the incompleteness of recollection. No memory can be described closely enough. The opportunity to identify and add points between another and the next persists
indefinitely.
(I tell myself to avoid being overwhelmed by the whole.)
There is great pleasure in looking at the infinitesimally small aspects of an experience
as well as the infinitesimally large.

Back to the curve

Nabokov wrote about the "whereabouts of the curvature. . . . If, in the spiral unwinding of things, space warps into something akin to time, and time, in its turn, warps into something akin to thought, then, surely, another dimension follows—a special Space maybe, not the old one, we trust."[7]

These descriptions of my experiences of *The Lightning Field*, accumulated over time, reconstituted in thought, form a curve of memory. Each detail is a point that marks a moment as it stacks in memory and time. These points, together, trace perception aligning into a crescent.

I remembered Merleau-Ponty's "spatializing space" and found the following passage:

> *Space is not the setting (real or logical) in which things are arranged, but the means whereby the position of things becomes possible. This means that instead of imagining it as a sort of ether in which all things float, or conceiving it abstractly as a characteristic that they have in common, we must think of it as the universal power enabling them to be connected. Therefore, either I do not reflect, but live among things and vaguely regard space at one moment as the setting for things, at*

*another as their common attribute—or else I do
reflect: I catch space at its source, and now think
the relationships which underlie this word, realizing
then that they live only through the medium of
a subject who traces out and sustains them; and
pass from spatialized to spatializing space. In the
first case . . . I am concerned with physical space,
with its variously qualified regions: in the second
with geometrical space having interchangeable
dimensions, homogeneous and isotropic. . . . Here
we want to confront it, not with the technical
instruments which modern physics has acquired,
but with our experience of space.*[8]

Visit I: October 18 and 19, 2003, continued
The long drive through the New Mexico landscape from
Albuquerque to Quemado to *The Lightning Field* is a gradual
slide toward emptiness,
a prelude.
Or a subtle preparation for the eyes and mind.
The practicalities of the cabin provide simple accommoda-
tions that address
basic needs
to maximize focus and minimize distraction.

At *The Lightning Field*, my experience of space began with
the rational structure of the grid, which was eventually
exposed by less rational behavior.

The artwork locates the physical environment in space, and
my perception
of the work began with the regularity of the grid.
The repeated unit of the pole was not significant, only its
holistic

engagement between human scale and the landscape and
the sky.
Then the effects of light,
the anticipation of cycles of change
through the course of the day and night,
the possibility of the unpredictable.

The cycle of the day led to an expanded view, beyond the
poles, leaving behind the limits of the mile and the kilo-
meter. The rational side of time and measurement
fell away.
The coin flipped.
The other side of time took hold.
(Irrational sister.)
Time and space were concurrently elongated and condensed,
as in the semiwakeful
state of insomnia,
alluding to infinity.
(When you cannot sleep the night lasts forever.)

On a micro-scale, the breadth of the landscape was captured
in each anthill. Magnifying the infinite surface of each com-
posite rock and particle of sand mirrored the vast landscape.
The relative relationship of space to distance was malleable,
and the mountains and sky
felt as close as the nearest pole or at an unfathomable
distance.

Later, at "The Lightning Field"
The sun's position in the sky shifted.
As it began to set, the sun's rays struck the poles at increasingly oblique angles.
The poles took on the look of the sky.
They changed color, deepening and distinct from the backdrop of the landscape.

At once and only briefly, the sharp tips collected the energy of the fading sun.
Each pole appeared to bear a tiny flame against the sky.

"Those flames could be real," I thought.

Nearly as quickly as they were lit, they extinguished themselves. The sun reclined over the westerly ridge, and the poles absorbed a red-pink-orange sunset.
Lurid, ridiculous colors for steel poles.
They flashed, ostentatious in the desert.

Soon enough,
the now-cool sky blanketed the hot colors.
Blue gray, steel gray, deep blue, midnight.
And then stars.
We watched for the moon.

> *A moon rising, edge so sharp*
> *you can feel it in your back teeth.*
> —Anne Carson, *Plainwater*

The five of us who made this first journey together spent the next two hours preparing and eating dinner, still reeling from the day's experiences. I had traveled with my husband, Josh, and dear friends, Mira, Melissa, and Lucas. We had spent the previous night in a B&B in Albuquerque. The owners were drunk on boxed wine when we arrived, barely able to assign us rooms. Each had a theme, the cowboy room for Lucas and Melissa, African landscape for Mira, and Josh and I in the putti room (even the faucets sported heads of little angels that swiveled disturbingly to turn on the water). The food nearly put us all into diabetic comas, although Mira was the only one brave or crazy enough to try the enormous pink cake on the stand in the kitchen.

Needless to say, the overwhelming austerity of our day and the field's log cabin were a significant contrast to the night before. We ate a subdued dinner of enchiladas and rice and beans, talking about the field. Our frames of mind and our surroundings had shifted considerably in the last twenty-four hours and we felt it deeply.

We wandered back outside.

As celestial points poked through a velvet darkness, the flat sky arched into a vast dome. We lay on the dusty desert floor and felt the density of space above.

(Other memories of entering cool interiors of Baroque churches in Rome with Mira;

allowing the retina to adjust to the low

light, walking up the aisle

to the transept, and taking in the majesty

of the painted dome,

the "sky" filled with saints and putti, simultaneously ephemeral and heavy as the stone and mortar of the church.)

The night sky weighed on us.

The constellations were clear and precise,

appearing to descend toward the desert floor.

(I could have touched them.)

> *That marvelous mess of constellations, nebulae,*
> *interstellar gaps and all the rest of the awesome*
> *show provoked in me an indescribable*
> *sense of nausea,*
> *of utter panic, as if I were hanging from earth*
> *upside down on the brink of infinite space,*
> *with terrestrial gravity still holding me by the heels but*
> *about to release me at any moment.*
> —Vladimir Nabokov, *Speak, Memory*

The Lightning Field is not a magical place.

It demonstrates an accumulation of specific experiences. Within the austerity of the desert, there are few distractions from the acts and implications of perception. Concentration is more easily achieved,

revealing the remarkable.

Chaos and scale

There is a fundamental difference between Newtonian paradigms and chaos theory. Newtonian science relies on individual units, and the idea that the examination of these units, over time, will coalesce into a fuller understanding of the system.

This genre of scientific exploration rests on examining parts that will shed light on their larger counterparts.

By contrast,

chaos theory

contends that the individual unit is irrelevant.

Instead, what matters is the recurring

symmetry between

scales within the system.

"Chaos theory looks for scaling factors and follows the behavior

of the system as iterative formulae change
incrementally. . . . It is a systemic approach, emphasizing
overall symmetries and the complex interactions between
microscale and macroscale levels."[9]

At *The Lightning Field*, I first relied on the regularities of
Newtonian principles,
relationships of measure, distance, and time.
I examined the grid and its individual components,
the poles:
four hundred poles demarcating the expansive grid,
four poles together creating a 48,440-square-foot unit.
I understood scale by walking the mile-by-kilometer
perimeter of *The Lightning Field*.

Over the length of the day, the experience of the work
extended
beyond the impact of the individual unit;
each pole,
each row or aisle,
outside of itself.
The patterning of the system can be understood through
repetition of form. The grid at *The Lightning Field* is irregu-
lar even in its regularity.
(A mile by a kilometer and six meters; variations in pole
height; mathematics in service of aesthetics.)

The grid is a simple tool,
a structure for experience beyond what is quantifiable.
Where does it end?

I realized that the poles are only a device for seeing something larger, infinite.

More mathematical histories that allude to the infinite
Benoit Mandelbrot's work from the 1960s and '70s embodies the development of theories of chaos and fractal geometry. His vibrant and swirling illustrations of fractals form psychedelic patterns that each repeat infinitesimally inside themselves.
They describe the relationship
between the very, very small and the very, very large, and we see
that they are similar.

Mandelbrot described the concept of consistency on varying scales;
"self-similarity" had been extant in scientific thought for centuries.
Is a sperm a miniature human, just greatly reduced?
Are whole universes contained in a drop of water?[10]
Perhaps these concepts were simply the result of limited

human understanding of scale?
Then, microscopes, telescopes, and other technological
advancements
revealed the inaccuracy
of sperm-as-mini-men, or
self-similarity.

Mandelbrot reenvisioned
self-similarity in nature through ideas of consistency on the
basis of scale.
He examined
fractional dimensions and mapped
"complex couplings between scales of different
lengths which are at the center of fractal geometry [and]
are found
everywhere in nature—in cloud forms, mountain contours,
tree grains."[11]

At greater levels of complexity, Mandelbrot located repeat-
ing patterns of scale that provided new information about
the behavior of whole systems. Repeating patterns
(as in a grid of steel poles in the desert)
imply this kind of infinity, the possibility
for endless
expansion and contraction.

The Koch curve, named for its inventor, Helge von Koch, reveals the affinities between Mandelbrot's ideas and his procedure for creating fractals. The Koch curve is an equilateral triangle;
each side's middle third becomes
one side of a second equilateral triangle to form a Star of David.
Add further triangles to each subsequent triangle to create an infinitely expandable
yet symmetrical geometric form.

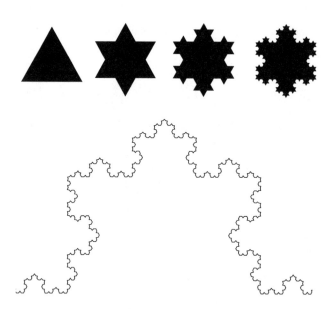

And the infinite:

while the form becomes increasingly complex through the addition of triangles, it remains too regular to reflect most natural phenomena. Mandelbrot reasoned that by adding an element of chance,

or error,

(or a sudden lightning storm?)

into the formula, he could increase understanding of the phenomenon, as most naturally occurring systems are formed in part by chance.[12] In fact, a string of Koch curves bears a striking similarity to a very regular coastline.

Adding the element of chance through algorithms is, according to Mandelbrot,

the "only mathematical tool available to help

map the unknown and the uncontrollable. . . .

The [traditional] physicists' concept of randomness

is shaped by theories in which change is essential at the microscopic

level, while at the macroscopic level it is insignificant.

Quite the contrary, in the case of the scaling random fractals that concern us,

the importance of chance remains constant on all levels, including the macroscopic one."[13]

Mandelbrot had his set of data for regularity; *The Lightning Field* has the grid, steel poles, and the predictability of the

day's cycle. To map the macroscopic, Mandelbrot's intro-duction of chance was algorithmic; at *The Lightning Field*, it is weather, light, insects, birds, plants.

Alternate algorithms.

Visit II: *July 15 and 16, 2004*

Thinking of Lorenz, I returned to *The Lightning Field* with a colleague and a friend of hers. The three of us occupied the cabin. Sarah handled public relations for Dia at the time; a lively and very thoughtful colleague, she, like so many others during my years at Dia, had become a friend. I didn't know Heather very well, but she was Sarah's pal.

Enter the unpredictability of nature against the regularity of the grid of steel poles in the desert. See what you see.

Again we arrived at midday. The sun followed us in the Suburban as Robert drove us through miles of desert and cattle guards to arrive at *The Lightning Field*. In the distance, over the southern ridge, we could see weather approaching. Gray-black clouds with diagonal smears extended toward the desert's caked surface, like eraser marks on a charcoal drawing.

How long would it take to arrive?

Would the storm shift westward, or cross *The Lightning Field*?
Would lightning strike?

Robert drove and told us about the surrounding ranch lands,
who owned them, which parcels were being sold off and
developed into ranchettes, how many head of cattle the
land could support.
We didn't see any cows.

The clouds were moving fast,
shadow and sun alternating above as we drove.

We veered off the rutted dirt road lined with juniper and
piñon trees and arrived at the cabin; the storm approached.
Robert thought we had two hours. We quickly went into the
poles, trying to gauge the impact of the changeable light;
white clouds passed swiftly;
one of us in shadow,
the other in sun as we separated,
avoiding anthills.

It was July, when it is said the incidence of lightning is
highest.
I remembered Lorenz. Patterns are unpredictable.
Elements of chance are always lurking.

The dark clouds approached, the sun faded, blocked by the
low cloud cover. Sarah, Heather, and I were scattered on
the south side of *The Lightning Field* and the weather was
rolling in fast, in a way that only happens in the West, par-
ticularly New Mexico.
It was an impossibly cinematic scene.
The gray smears overhead came closer.
We retreated to the cover of the cabin's porch.

The temperature dropped dramatically.
The wind intensified.
A cluster of small white butterflies hovered
agitatedly in front of the porch, between
us and *The Lightning Field* and the storm.
(Lorenz, Nabokov . . .)

We watched distant lightning, wondering if it would stay
on track,
moving from the southeastern ridge toward the cabin to the
north and west.
As branches of light sprawled across the distant sky,
splintering at severe
angles, we counted and waited for thunder.
We measured the distance of the storm.

> *Many-hued, breaking into infinite fragments,*
> *multiplying itself lightning flash on flash,*
> *it leapt the platform and was scattered there.*
> —Boris Pasternak, *Safe Conduct*

The storm soon arrived at the southern limits of the poles.
Lingering above the grid, and in stark contrast to its linear arrangement,
webs of lightning sprawled and contracted against the slate-colored sky.
As these tangles hovered over *The Lightning Field*, I held my breath.
The light and sound came almost simultaneously.

> *Brandishing a wild twig as though it was lightning.*

> *The summer lightning would be playing . . .*
> *surprised by a transparency, as though by an illness,*
> *sapped from within . . . the sky was restless.*
> —Boris Pasternak, *Safe Conduct*

The lightning flashed in stark contrast with the regularity of the poles. Despite their height, the poles did not attract the splinters of light. The weather remained high above.

The storm intensified.
Large drops of rain fell, and quickly froze.

We sat on wood benches on the porch, seeking some shelter from the weather.

Crystalline, bead-like hailstones bounced off the porch's wooden floorboards; strong winds blew. We moved inside the cabin, leaving the back door open to see the storm framed in the wooden

doorway, unmediated by glass.

> Outlined by the black door of the passageway,
> a silvery grey storm sky mirroring over the patio—
> pierced by lightning and herons.
> —Severo Sarduy, Cobra and Maitreya

It was dark outside for daytime, darker still in the cabin.

The hail increased in size, and the wind picked up. Dime-sized hailstones

careened from the porch to inside the cabin through the open door, and despite the early-afternoon hour, the sun was completely

obscured

by soot-tinted storm clouds.

Wind and hail blew through the door; the gusts too strong to allow us to keep it open to watch the weather. So we peered outside through the small south-facing window. Hailstones pelted the roof.

The sound of their dull pings was regularly
overridden by claps of bass-heavy thunder.
My sternum reverberated.

Outside, the poles were steely gray, reflecting the flat
light caught in the clouds rather than hot flashes of lightning.
The grid didn't change.

Inside the cabin other distractions materialized:
floorboards, slightly warped, a hair's width separating one
from the next.
Normally they admitted fine desert dust, but today, fleeing
from the storm,
flying ants emerged.
Hundreds surfaced from between the boards, swarming inside
the cabin.
(Robert told me later: this was their mating season.)

We flung the door open and were caught at a border between
tiny flying beasts and jagged
hailstones,
the violence of nature.

WATER RAINING.
Water astonishing and difficult altogether
makes a meadow and a stroke.
—Gertrude Stein, *Tender Buttons*

Hail turned to punishing rain, as the temperature rose slightly.
The ants left as quickly as they came.

> *By afternoon it is darker, thunder comes*
> *down the hills. . . . Outside, rain streams. . . .*
> *Roofs pour, the gutters float with frogs and snails.*
> —Anne Carson, *Plainwater*

Rain passed over the cabin,
now a softer sound against the roof.
And the low obsidian clouds dispersed, revealing a logy sun
setting over the western ridge.
There would be no luscious sunset tonight.
The poles picked up the dying light, glowing
an anemic gold against the gray saturated landscape.
The weather had passed. It had only taken thirty minutes.

> *The rain, which had been a mass of violently*
> *descending water . . . was reduced all at once to*
> *oblique lines of silent gold breaking into*
> *short and long dashes.*
> —Vladimir Nabokov, *Speak, Memory*

> *[It] no longer seemed like something dangerous.*
> *It felt like slowly dripping warmth from a molten sky.*
> —Matt Briggs, *Shoot the Buffalo*

We wandered outside, stunned by the storm.
We avoided brown eyes of pooled
rainwater that accumulated in valleys between anthills.
Soaked, the vegetation had lost some dustiness.

I walked around the cabin, and on the west-facing porch
discovered
a thick carpet of dead and dying ants.
They must have slid from the roof,
the rain
washing them from its easy slope.
Their appearance and disappearance in the cabin was
sudden and peculiar.
And then, there they were, millions (?) of them, dead,
waterlogged, and piled at least two inches thick on the
soaked wood platform.

Why did they fly into the cabin and leave so suddenly?
Did the hail and rain kill them or were they already dead
on the roof?
If so many died during the storm, I imagined the
extraordinary
number of these insects that must live in the entirety of
the desert.

As darkness swept the sky, the clouds moved northwest, away from *The Lightning Field,* and the coyotes began. The sound was thin at first,
its pitch as tentative as the setting sun.
But the coyote sounds strengthened,
perhaps growing in number
or proximity.
We couldn't tell, but we ate dinner to their disquieting serenade.

> *There were stars and chunks of eternity, poems like suns*
> *and enormous faces of women and cats where the fury of*
> *their species was fired up . . . in their own language*
> *where words were woven night and day into furious battles.*
> —Julio Cortázar, *Hopscotch*

The night sky was clear, too many stars.
Satellites described distinctive arcs, moving too fast for nature across our broad field of vision.
The desert floor was drenched with rainwater, and our boots suctioned the mud.
The moon's shy face revealed only a sliver, but the starlight was strong enough for the poles to pick up its silver.
We watched time, light, and distance compress over *The Lightning Field.*

The dome of the sky was palpable,
papered in stars.
How long ago did the light that reflected in the poles leave
its source?

> *Star-light, what is star-light, star-light is a*
> *little light that is not always mentioned with the sun,*
> *it is mentioned with the moon and the sun,*
> *it is mixed up with the rest of the time.*
> —Gertrude Stein, *Tender Buttons*

I went to bed, leaving my light on long enough to attract a
flurry of delicate moths.
(Nabokov, Lorenz . . .)

> *Like moons around Jupiter,*
> *pale moths revolved about a lone lamp.*
> —Vladimir Nabokov, *Speak, Memory*

Then I slept. Maybe I was getting used to the elevation, to
the extremes of this place. I would like to stay longer.

I woke up early, before sunrise, and went outside. The sun
was at the cusp
of the ridge, ochre rays
preceding its arrival.
The sky was already a lucid blue.

The weather of the day before had brought out animals;
the low brush home to many species that appeared only at
prescribed times of day.
Coyotes at night,
jackrabbits and birds in the early morning:
at the edge of my peripheral vision,
I saw a flying object about four inches in diameter.
(After the ants, I assumed it was a massive desert insect.)
It buzzed as it flew,
darting erratically,
from one cluster of plants to the next.

As it dashed past, I saw that the mass was actually two
delicate creatures.
Hummingbirds.
They were both bright and iridescent,
one green,
the other red.
They flew with wings blurred by the speed of their move-
ment, so close to one another they seemed to be one object,
circling one another, looking for desert flora the
rainfall had called from hibernation.

As though reflecting the hummingbirds' plumage, the poles
became lustrous; the sun warmed the air. Their sharp tips
lit up, as at sunset on my first visit,

but more subtly in the graceful morning light. They retained
their gray iridescence,
reflecting the sky.

Robert Weathers arrived at 11:30 a.m., cracking open a can
of beer as he rounded the cabin and joined us on the porch.
He asked after the storm, and we reported the strange effects
of the weather, showed him the dead ants, described the
disquieting flatness of the light and
the calls of the coyotes.
He was, predictably, unimpressed.

A memory from 1975
De Maria was contemplating *The Lightning Field* in the
American West, and despite the Cold War, my family
lived in the gray city of Bucharest on the wrong side of the
Iron Curtain. I was young, and now recall only some of the
points on this curve of memory. Despite the radical differ-
ences between the two locations, the residue of this time, in
my recollections, finds a parallel in the light, weather, and
sense of place that I later experienced in New Mexico. How
reliable is memory?

I think the window was dirty, but maybe not.
The sun shined a little, so I moved the white curtain, which
was long but easy to move. Even when the curtain was in front

of the window, I could see through it a little, vaguely. I moved it with my hand, and opened the window, thinking it might be warm outside. It wasn't the right time for it to be warm, but it would have been good if it were, because I wore only my flannel nightgown.

The window wasn't easy to open because it was new, although not actually new, quite old, just new to me. The handle was different from the one at home,
but now this was home, my room.
The handle was old and shiny from lots of hands (but not my hands),
and the glass was tall and narrow and quite different from my old window.

It stayed open, despite a little wind. And I wasn't cold, so it must have been warm, but the sun was warm, not the air.
The long, white, and almost-transparent curtains,
which were also
new-but-not-new, swayed gently in the wind.

I looked out the window and there was a little green outside, but it was mostly gray.
The green was from a city, not the country,
but it was a nice, bright yellow-green. Since it was still cool I could tell that even though the green was small and bright now, it might get a little

bigger and darker soon.
Gray was more common.
Most of it was dense, and it was dark and wet in some places
and light and dry in others.

The window was open, and the sun was warm even though the
air was still cold, and the air smelled like food that I had never
eaten before.
Sour and sweet and savory, the food
smell mixed with the outdoor city air.
I would eat the food and know the smell of it being cooked.
My neighbors must have been making it.

There were other windows,
and their buildings were mostly gray.
I recalibrated my vision;
I made the windows change.
Small squares and larger rectangles,
many sizes and permutations of window,
nothing close or far,
everything just there.
Even the curtains, most of them white, some of them lace,
some blue with a pattern, or red.
There was only one yellow, so that one was special.
But none were closer or farther, they were all just there. Because it
was warm, some were open, so the curtains moved. This made

it more difficult to keep the windows in their big flat pattern,
but I did it. Until I stopped, and I didn't mind.

Sometimes the window across the way was open.
The white curtain behind that window moved. Sometimes wind
shifted the fabric,
sometimes a hand moved it.
A boy's hand.
He didn't move it away, he just touched it.
Later, I would see him and his name was Cosmo.
I didn't know this yet, but I would know it once I knew the taste
of the food
that made the air smell.

Cosmo stood in front of the curtain, positioning
himself between the curtain and the window.
He was there, looking out the window, and he was wearing
a jacket.
It wasn't a jacket to wear outside when it was cold, but more a
jacket that was small and soft, and had a zipper on the front.
It was blue, very blue, and light
blue, and had a black zipper on the front. When he turned
around, it had a hood on the back.
I liked the hood on the blue, blue jacket very much.
I wanted my red-apple jacket with the hood on the back.
That was my favorite. And I remember it.

But Cosmo was there and he turned around, and that's when I
saw his hood and wanted my apple jacket. I didn't get my apple
jacket, because he turned
around again and looked at me again.
This time he had a flag in his hand,
and it was my flag and not his flag,
and he waved it and smiled.
I knew it was my flag and could not have been his flag,
because I knew his flag was yellow.
I think I smiled and wished I had his flag;
the yellow flag would have been nice,
but maybe I didn't understand that until later.
Maybe it is a point on the curve that I added later, remembering.

And Cosmo was at the window across the way.
He was standing between the window and the curtain,
which I could almost see through.
And his blue, blue jacket with the hood reminded me of my
apple jacket,
which I didn't want to get
because I didn't want Cosmo to go away.
Then he turned around and I saw the hood,
and when he turned around again, he had the flag that he waved
and he smiled.
I didn't know his name was Cosmo yet, and I hadn't tasted the
food that made the air smell sour and sweet and savory, not yet.
And the flag was my flag,

not his flag,
and that is why he smiled, but I don't think I understood that
until later.

And it all took time, and I didn't mind.

In the United States
At around the same time that Cosmo waved his flag across the alleyway in Bucharest, Walter De Maria was driving across the western United States with Helen Winkler looking for a site for *The Lightning Field.* I visualize their journey, crisscrossing the landscape. De Maria had made a smaller "test field" in Arizona in 1974, and data and information gathered through observation of this test site helped determine the specifics of the New Mexico artwork. They conducted research on areas with a high incidence of lightning. They wanted a spot where lightning struck more frequently than anywhere else.

What if De Maria had corresponded with Lorenz? An imagined conversation:

> *De Maria: Where is lightning likeliest? Where is*
> *isolation greatest? Where is weather most intense?*
> *Lorenz: Couldn't tell you, Walter. But I hear the*
> *weather in New Mexico is unpredictable. I could*

> run some data for you . . . The Royal McBee is at
> your service . . .
> De Maria: I've seen your butterfly. It is beautiful.
> Lorenz: Yes, it is beautiful, and small irregularities
> among the regular data make it so.
> De Maria: I knew you would understand. I'll
> remember your butterfly as we drive.

Building "The Lightning Field"

At the cabin, a binder of materials provides a history of the project for visitors. The texts offer technical information about the survey of the land, the fabrication of the steel poles, the timeline of the construction of the project, as well as De Maria's statement about *The Lightning Field* published in *Artforum* in 1980. These documents, highly quantitative in content, cite

heights,

weights,

diameters,

measurements,

and list the group of technicians, consultants, and other workers who played a role in realizing the artwork.

The artist Terry Winters was among the original crew, and on June 5, 2006, I saw him give a lecture about his work on *The Lightning Field.*

He talked about the late 1970s and the feeling of the time:

seeing the first "blue marble" photographs of the earth
coming back from
NASA excursions into space in 1969;
the emergence of the "whole earth" movement and "ecological thinking";
music and film adopting "space" as a subject;
the popular interest in Los Alamos, and Roswell, both in
New Mexico.

Winters talked about De Maria's chosen site as the least
populated place in New Mexico, and noted its location
west of the continental divide.
He described lightning striking in the "empty" desert;
how it hovered over the New Mexico landscape.
He talked about understanding how close the lightning *felt*
rather than how close it *was*.

Winters spent four months working on *The Lightning Field*.
The crew hired kids from Pie Town (where Robert Weathers
grew up) for $2.65 an hour who were supposed to be at least
sixteen years old (one was fourteen); they fought over who
got the heads and rattles of the rattlesnakes they killed. A
retired rodeo horse named Payday lived on the land and
members of the crew occasionally rode him. He died there.
There was also a windmill on the site, which was dismantled.

Since they were working far from a hardware store and other sources of supplies, the group had to be inventive. The space that is now the visitor's office in Quemado was a shop for polishing and cutting poles. There were two shipments of poles, and the second arrived damaged. Since refabricating them was impossible, an oil-pipe manufacturer in Fort Worth was called in to straighten the imperfect ones. At the Quemado shop, they used roller-skate wheels to rotate the poles while polishing them, while a crew worked at the site to survey, level, measure, and determine the exact placement and height of each pole. The crew developed steel tripods to hold them in place and to check the height prior to their permanent placement, as well as a durable footing system to guard the poles from high winds. The crew wore white gloves to install the poles. All meetings were held in the relocated 1930s homesteader's log cabin that would later serve as the guest cabin for visitors to the site. Once the project was complete, Helen Winkler and her husband, Robert Fosdick, who had engineered and organized the better part of the project, lived in the cabin at *The Lightning Field* for two and a half years.

When *The Lightning Field* was finished, the work crew went to Las Vegas to celebrate, and took in Dionne Warwick's show at the Sands.

Isolation

De Maria's 1980 text on *The Lightning Field* provides several statements that fall into neither a quantitative nor anecdotal category and perhaps relate most directly to his wishes for the experience of the artwork beyond an appreciation of the measurements and coordinates, and the process of its construction:

> The land is not the setting for the work but a part
> of the work . . .
> The sum of the facts does not constitute the work
> or determine its esthetics . . .
> The invisible is real . . .
> Isolation is the essence of Land Art.[14]

I talked with Helen Winkler about the land surrounding the artwork. The experience of visiting *The Lightning Field* is predicated on its isolation in the landscape. It is imperative that the viewshed be maintained:
ridges of mountains east and west,
to the south a more distant eruption of rock, the Sawtooth Mountains.
Even in this remote area, isolation is at risk.

For the purpose of measurement, land is divided into sections, each of which comprises 640 acres, or one square mile. Often, federal land is checkerboarded amid private properties.

Helen Winkler has mapped the ownership of each parcel surrounding the artwork on a detailed topographic map. *The Lightning Field* is located within a block of 21.25 square miles owned by Dia Art Foundation. Dia also holds leases on two sections of state land. Heiner Friedrich, a founder of Dia, owns three sections to the west of the field as well as the ridge cabin, which has been home to *The Lightning Field*'s caretakers for many years. Lannan Foundation owns a number of key properties, purchased to protect the area from development. The Bureau of Land Management, a federal agency, controls some important sections to the south.

And then there are the ranches. The McPhaul Ranch is among the largest and most important to the viewshed. Now owned by a third generation of cattle ranchers, this is the land most visible just south of *The Lightning Field*. To the east and south of the field is the Lehew Ranch, with parcels owned by Rufus Chote. It is situated adjacent to the McPhaul properties. When I asked who owned the Lehew Ranch, Helen told me she wasn't sure, and relayed the following story about the death of John Lehew:

John Lehew's son lived in Pie Town.
Lehew, an old but solid rancher lived alone on his land.
His son thought he needed help,
someone who could check in on him regularly.

Someone nearby.
So he didn't have to make the hour-and-a-half
drive from Pie Town to the remote ranch as often.

The son installed a trailer near the old man's
house and had a couple of friends of his move in to check
in on his dad.
They ran electricity to the trailer off the original lines to
the house.

John Lehew did not like this arrangement.
There were disagreements, arguments, angry words.
Lehew ran his son's friends from the property with a shovel.
Fuming, Lehew decided to disconnect the electricity from
the trailer despite
the lateness of the day and the visible
storm clouds in the distance.
He began his work high on a ladder, cutting the
current to the trailer, returning
things to the way they should have been,
cursing the arrangements his son had made.

While disconnecting the wires, Lehew took a fall.
He broke his arm, and a couple of ribs.
He could not get up.

Knowing it was getting late, and that rain
would soon pass over the ranch, Lehew dug
a depression in the earth to protect
himself from the elements
and the drop in temperature that would follow
the setting sun.

The next day, the son heard from his
friends that the old man had thrown them off the ranch.
He tried to call his father, but the rings went unanswered.
He called Rufus Chote.

Rufus lived miles
away, but he was closer than the son in Pie Town.

Chote drove to the ranch.
The sun had emerged, after the previous evening's storm.
When he arrived, he saw his friend in the depression in the
earth, caked in mud.
He thought Lehew was dead.

As Rufus approached the mud-caked body,
John's head moved.
He looked up at Rufus
and said,
"Good weather we've got on here."

Rufus called the paramedics in Pie Town, who sent a helicopter from the nearest hospital to medevac John to the emergency room.

It was a miracle he had made it through the night.

At the hospital, John held on for a few days, but in the end, he died of hypothermia.

Visit III: June 19, 20, and 21, 2006
On previous visits, I knew that spending more time at *The Lightning Field* would deepen the experience. I also wanted to go alone. Staying for two nights would provide me almost sixty hours to resensitize and experience the work.

I wanted to stay longer.

Stephen and Elizabeth, two artists from Los Angeles, were also staying in the cabin on my first night at the field. At first I was distant, wanting to retain anonymity. Over the hours, I found that Elizabeth and Stephen were ideal strangers to encounter in such a setting. They had long wanted to visit and had spent a great deal of time imagining the experience. And they were both photographers, making their observations and our conversations that much more interesting. They were keen observers, particularly of light and shadow, and liked to talk about the small details of their wanderings in the field. Elizabeth was animated and rangy, and Stephen, bearded and laconic. We spent our

twenty-four hours together mostly out in the field, usually in wildly divergent areas. We came together before meal-times to share what we saw, felt, thought, heard. We remain friends today.

4:03 *p.m.*
Just inside the northernmost line of the poles,
I looked to the south;
twenty-five miles to the Sawtooth Mountains.
Fifty miles away, Alegres Mountain was smiling,
just west of the Sawtooths.

The sun was still too high to see
the poles distinctly, but to the west, the nearest
rods bore the mark of a shadow
on their eastern faces.
A dust devil danced in the distance,
coiling and uncoiling like a ghost of a pole.
It spiraled upward,
tall,
thin,
sandy beige,
muted mauve.
It dispersed as the wind died down and picked up again.

Winds from the nearby volcano streamed
across the still town . . . tugging at the strands of
her hair; old leaves spun unreasonably into
corners before gusting away in
blasts of air.
—Stacey Levine, *Frances Johnson*

It was windy, and dry as kindling. Someone in Albuquerque predicted the desert would be brown and parched due to the hundred-year drought and that there would be no green anywhere. On the drive out, I asked Robert Weathers about the effects of the drought. He said it was no worse than any other year.

"People just want an excuse."

Standing in *The Lightning Field*, my eyes teared and nose ran, despite the intense heat and dry wind. My body was the wettest thing for miles.

6:15 p.m.
From the porch, half of the poles were silver, half black.
There was a curtain of haze between *The Lightning Field* and the Sawtooths.
Robert mentioned that to the south, miles beyond Alegres, a fire
had burned for days.

The smoke and debris traveled
north with the winds.
(How did the shadows smell? Of cedar and piñon mixed with
bitter smoke,
far away.)

As the sun descended,
raking through white cumulus clouds,
the fine particles of detritus, burned
brush and wood,
created mile-long pearl-gray
diagonals in the sky.
They were faint but spanned the distance between clouds
and horizon,
as though a comb had been dragged
across the smooth, placid
surface of the sky, incising
its uniform blue with parallel strokes.

> *Hills rise in masses, flat on top.*
> *White clouds bite down on them like teeth.*
> —Anne Carson, *Plainwater*

The tips of the poles absorbed and reflected the setting sun.
And in that moment, oblique gossamer strands of light
extended down from the clouds,
grasping for each ignited tip.

> *A sunset, almost formidable in its splendor, would be*
> *lingering in the fully exposed sky.*
> —Vladimir Nabokov, *Speak, Memory*

8:25 *p.m.*
The sun was well on its way west.
I remembered that in October, the sun set along the ridge due
west of *The Lightning Field.*
In June, it set parallel to the cabin,
further north, describing a different arc.

> *Sometimes appearing at the head of nature*
> *it raced the sun.*
> —Boris Pasternak, *Safe Conduct*

The day was very long because the solstice was
only two days away.
Sitting among the poles,
I leaned against one.
In this position, I sat at the hub of a wheel,
in line with the rows and columns.
I sat, cross-legged, feeling the pole trace
my spine. It extended up some twenty feet over my head
as I was simultaneously
rooted to the ground and reaching
toward the sky through its pointed cone.
The wind made the pole tremble,

and my vertebrae echoed its hum
in sympathy with the steel.

The poles captured the golden light of the hot
globe as it withdrew,
and seemed to expand,
taking a deep breath,
growing thicker.
Their edges, so sharp earlier,
shimmering.

The wind picked up in intensity and the
sky was reflected in the poles.
All four hundred glimmered scarlet;
an electric ribbon of color surged up and down each shaft.
The poles vibrated with the wind,
the reflected light flickering in time with the movement of
the air.
When the wind eased, laser-precise red lines bisected
each golden pole.
A vertical stripe,
plumb line.

In the distance, a streaming, miles-long plume of smoke over
the Sawtooths expanded, veiling the sky above the eastern
half of *The Lightning Field*.

June 20
I slept, but woke periodically to check for dawn:
2:53 a.m.
3:27 a.m.
4:08 a.m.
5:03 a.m.
Up. Dress. Outside.

I stood in the hard and cold predawn light. The smoke
from the distant fire had dispersed into a miasma of light-
gray tulle over the eastern third of *The Lightning Field*,
meeting the horizon.
Would the rising sun be visible?
I walked east to watch the sunrise on the skin of the poles.
Unusually, the surface facing the sunrise was darker than
the other half of the poles; they picked up the reflected light
of the lightening sky.
Silver.

Sitting down, at the crossroads
of the easternmost and northernmost poles,
I watched the grid
catch the tangerine of the rising sun.
Light filtered through a cataract of graphite
smoke, subtle and soft.
Each pole appeared to be levitating

above the desert floor.
They had lost any girth
gained in the red-gold of sunset the night before.

11:48 *a.m.*
I said good-bye to Stephen and Elizabeth and knew I would
be on my own for a few hours before the next group of visitors
arrived. Robert said they would be late. We were expecting a
group of Austrian architecture students and artists who were
in-residence at the Rudolph Schindler House in Los Angeles.
I went back out into the field.

The poles were white, opaque.
By 12:15 p.m., they turned black,
solidly planted in the earth. They obeyed gravity.

The wind stopped. Walking through the poles was a very
different experience;
no wind, only dry grass
crunching underfoot.
Without constant wind swirling
around my ears,
the sound of compressed dry plant life dominated.

I walked farther on and found myself in a standoff with a
jackrabbit.

He was three feet away. His ears a third of his height. A
shiny golden
eye staring at me;
both ears
pointed in my direction.
His radar, light pink like the inside of a shell.
Nose twitching.
Who walks off first?

Moments later
(or it could have been an hour; time slipped),
in an absolute quiet, I thought I heard a car
approaching in the distance.
I trained my eyes in the direction of the sound.
It drew closer, but it was not mechanical.
It was wind accelerating
miles away, past the southwest edge of the poles,
closing in.
The grass waved in the distance,
its motion a hint of the air's progress.
Swiftly, the wind swept
over me, and departed to the northeast.
The rustle of the brush yielded again to quiet.

Topography
I walked along the southern side of *The Lightning Field*,
crossing over

hard-packed, virtually vegetation-free earth,
soft, dusty sand scattered with tufts of grass growing in
circular formations.
(Recalling aerial views of crop circles? Weirdly perfect.)

Next, I noticed
white flowers dotted the landscape, their heads too large for
minuscule stems.
Then knee-high scrub was accompanied on occasion by
small cacti,
some with an eccentric, solitary
electric-yellow or hot-pink flower.

There were also large depressions in the landscape
amid the poles.
These measured some 125 feet in diameter and were
blanketed
with grass and small flowers;
blooming lavender, white, yellow; water-conserving, succu-
lent leaves.
The soil was the color of burned
toast; a carpet of plush earth.
Invariably these depressions were ringed by taller wispy
grasses with wheat-like, downy
protrusions—all light green—the drier ones verging on lilac.
These, backlit by sunlight, glowed as they swayed in the wind.

The wind, variable in intensity but constant,
rustled the dry grass and brought weather from the south.

> *The cloud threw a glance at the baked and*
> *undistinguished stubble earth which lay scattered*
> *over the horizon. Gently the cloud reared upwards. . . .*
> *The cloud fell on its forelegs, and . . .*
> *noiselessly crawled along.*
> —Boris Pasternak, *Safe Conduct*

Adding to the slight motion of the grass in the wind,
the early-afternoon sun produced heat
ripples on the horizon.
The edge of the ridge vibrated
liquidly, and the landscape beyond
The Lightning Field undulated, unstable.

The twitching grass was on alert as the clouds rolled
closer and fat drops of cold rain fell
improbably through unrelenting sunshine.

> *Large drops of rain pelted down on the*
> *dry riverbank stones, kicking up dust for a second,*
> *and then everything was wet.*
> —Matt Briggs, *Shoot the Buffalo*

I retreated to the cabin.
Ten minutes passed and the rain ceased.
I returned to the poles where the wind had let up but
threatened
to return.

"There could be more rain from the look of those clouds,"
I thought.

I sat, which quieted the crunching grass underfoot.
The wind had subsided.
Coyote.
Bold, well fed, trotting at a leisurely rate.
I was surprised he came so close; he meandered,
knowing it was his territory.

It didn't rain again.

5:06 p.m.
By this time the students had arrived and settled into
the cabin. I stayed out in the field greeting them as they
walked by.

The poles as sundials.
They cast soft shadows; their west faces
picked up the dim sun

despite the clouds.
Silvery, the steel began to take on a tint of the
camouflage-toned
desert and brush.
A prairie dog paid an uninterested visit.

6:43 p.m.
The sun began its recline and the tips of the poles gathered
a wash of mercury
that spilled down each shaft.
There were no clouds in the west
where the sun would eventually
disappear, but to the east and south, a tangle of white and
oyster blue hovered
like dye dropped in clear water.

Above, a hawk coasted on stiff wind in figure eights;
wings taut;
end-feathers spread, separated.
As the bird dipped to turn,
the pale down of its underside
caught the dying light of the sun.

The sky over the Sawtooths remained hazy; smoky rem-
nants of the fire. At this time of day, every few moments the
sun intensified its effect on the grid,

adding where it didn't seem possible to add.
Despite the haze, the crenellated
ridge of Alegres picked up the warmth of the setting sun.
The mountain's face took on a peach tone in contrast to
her sapphire
sisters to the west.

The distant poles looked peculiar,
as though their midriffs could not reflect the cool
gray light as intensely as the bases and tips.
They floated, released from their foundations.

The color of the brush began to emerge as the bleaching
effects of the high sun subsided.
The bright star sighed, setting.

8:20 p.m.
Lime-green, sage, and deep-mulberry grasses.
Thistle and cotton-candy-pink clouds spun in threads,
diminishing to an attenuated tail of color.
The poles deepened from silver to gold as the sun
approached the edge of the ridge.
The poles inhaled, expanding in circumference,
refracting the extraordinary setting sun.

To the west, the poles picked up fuchsia,
while those on the eastern

edges seemed diminutive with quivering tips,
flame-like.

Color intensified to its zenith
for an instant
before all warmth was extinguished.
The sun slipped below the ridge.
The distant mountains bled into the sky.
Clouds retreated, adopting the dusty dark;
monochrome returned to the cool sky.

The sky was again tied to the desert floor by the argent grid,
guarding the frontier between land and sky.

A bold buck appeared at the eastern edge
of *The Lightning Field*. He was not afraid and continued his
grazing westward.
(Robert had said that during antelope mating season, smaller
bucks are temporarily excommunicated from the herd.)
As the sun diminished,
he came closer,
finding more succulent grass in the depression in front of
the cabin.
There, vegetation was revived from the recent rain.
It was dark before he retreated.

I stood among the poles.
The vegetation once again molted its verdigris
in the dying light.
Ashen tones returned to the landscape; a last luminous
splash of light,
a final metallic effort
distinguished the poles from the now indistinct ridges of
mountains at the borders of *The Lightning Field*.

Poles glowed for a few more moments,
fanning westward into infinity as I walked past each row.
Patterns discernible,
chaotic,
discernible again.
My pace dictated their changeability.

The first star emerged despite the relative lightness
of the sky.
Directly up.
All the poles pointed the way to the light,
orienting,
disorienting,
losing-regaining-losing the grid.
Plant life glowed in twilight.

The poles held their opulent sheen long
after the mountains gave up indigo for inky black.

The landscape was stupefied by the sun's disappearance;
the speckled, liquid night sky took over.

> Overhead . . . the night sky was
> pale with stars.
> —Vladimir Nabokov, *Speak, Memory*

That night I learned how irritating the students were. Their
questions were a pebble in my shoe, so I avoided them and
went to sleep early and got up before dawn.

5:38 *a.m.*
Predawn honey light bathed the field.
A dog barked.

6:09 *a.m.*
The sun crested the easterly ridge,
rising patiently, wearily.
Beginning with the pole closest to the sun, the pole at the
northeast corner of the grid, in a wave, each took on the dull
light of the dawning sun against mountains,
still in shadow.

A dog barked,
far away in the windless morning cold.
Birdsong the only other sound.

6:16 *a.m.*
The pole tips on the east and north rows swelled
as the southwestern diagonal went aflame
with the rising sun's now-bold light;
flickering in the cold.

An intense focus of gold resided
six inches from the ground on the pole directly in front of me.
Light had not yet migrated.
The brush glowed with the raking rays of the warming sun.
The clarity of the air and the contrast
between flaxen
poles and brush, land, and sky made visible the farthest
poles in the deep distance.
I knew I could see them all because I had walked
the perimeter.
I knew its limits,
that it does not go on forever.

The sky understood no mediocrity.
The distant poles went violet, filmy;
closer poles were sharply articulated,
the rest losing their mass
as the daily cycle of the sun reached its apex.

At noon, I left *The Lightning Field,* once again recalibrating
time and space.

Infinity, unpredictability
This diary is incomplete.

A calculus exercise I would rather not solve.
Infinity and chance reside at each point
along memory's curve
(like a long night spent waiting for sleep to come).

Calculating time and space through mathematics and
measurement
represent methods of rationalizing
a point within the universe.
The experience of that location swells
with accumulations, additions, barnacles,
observations, thoughts.
Not just errant
memories but other intrusions affect the curve:
applications of chaos,
scale,
unpredictability,
infinity.

The Lightning Field presents measurement, space, and time
in combinations
that alternately adhere to and confound regularity,
suggesting something far less rational, like the inaccuracy

of a memory, or the way lightning
sprawls across the desert sky.

Looking deeply is a question of scale:
How close? How far?
It may not matter, you might see the same thing.

Theories of chaos present a universe within which the layer-
ing of scale and facture offer an alternative view. I subscribe.
The Lightning Field evokes references to perfect geometries,
infinities, and the incremental expansion of the universe. The
artwork proposes a phenomenological responsibility:
digest the experience,
become physically, visually engaged.
Remember.

Visit IV: July 23 and 24, 2008

Driving via the Pie Town road, I took the back route to *The Lightning Field*, arriving just after nine in the morning. After several meetings, including a drive through a ranch that was for sale, I returned to the field at noon for lunch, and later, dinner. Robert Weathers, Helen Winkler, and Kathleen Shields (*The Lightning Field*'s administrator) were all there. They each had known *The Lightning Field* the longest.

I thought of the red-tailed hawk we saw earlier that day. It soared with a
squiggle in its talons,
a snake!
The bird was soon joined by a rival for this tasty prey;
a pursuit ensued.
The first hawk lost its prize to the second,
a more fierce competitor.

I got out into the field at two.
Light rain, gray smudges toward the northeast and southwest. The southwest lit up first, the lightning brilliant against a darkening midafternoon sky.

I counted the moments between thunder and lightning
strike; the storm was still four miles away.
I sat down with my back to a pole to watch the two storms
flanking the field approaching. Branches of lightning
illuminated dark
patches of sky.
Some single bolts, striking straight down,
linking clouds to earth.
Others sprawled,
crinkled and irregular, crackling in
various directions,
a web across the sky.

Then west, just north of the field, lightning from a seem-
ingly clear patch of sky.
A straight and narrow
brilliant burst of light.
The other two storms advanced.
From the southwest, the lightning now flashed closer,
within three miles.
Thunder rolled.

A lone black crow,
broad wingspan,
flew low and stark against darkening southwesterly clouds
and silver poles.

Endnotes

1. Walter De Maria, "The Lightning Field (1980)," 527.

2. Ibid., 529.

3. Bourdon, "Walter De Maria: The Singular Experience," 40.

4. Gleick, *Chaos*, 23.

5. Ibid., 23.

6. De Maria, "On the Importance of Natural Disasters (1960)," 527.

7. Nabokov, *Speak, Memory*, 301.

8. Merleau-Ponty, *Phenomenology of Perception*, 284.

9. Hayles, *Chaos Bound*, 170.

10. Gleick, *Chaos*, 115.

11. Hayles, *Chaos Bound*, 165.

12. Ibid., 166–167.

13. Ibid., 167–168.

14. De Maria, "The Lightning Field," 527–530.

Bibliography

Antin, David. *i never knew what time it was.* Berkeley and Los Angeles: University of California Press, 2005.

Baker, Elizabeth. "Report from Kassel: Documenta VI." *Art in America,* September/October 1977, 44–45.

———. "Artworks on the Land." *Art in America.* January/February 1976, 92–96.

Barthes, Roland. *A Lover's Discourse.* Translated by Richard Howard. New York: Hill and Wang, 1978.

———. *The Pleasure of the Text.* Translated by Richard Miller. New York: Hill and Wang, 1975.

Baudelaire, Charles. *The Painter of Modern Life and Other Essays.* Translated and edited by Jonathan Mayne. 2nd ed. London: Phaidon, 1995.

Beardsley, John. "Traditional Aspects of New Land Art." *Art Journal* (Fall 1982): 226–232.

Beeren, Wim. *Walter De Maria.* Rotterdam: Museum Boymans-van Beuningen, 1984.

Boettger, Suzaan. "Behind the Earth Movers." *Art in America*, April 2004, 55–63.

Bourdon, David. "Walter De Maria: The Singular Experience." *Art International*, December 1968, 39–43, 72.

Boyd-Brent, John. "Harmony and Proportion: The Square Root of 2." Accessed August 12, 2016. www.about scotland.com/harmony/prop7.html.

Briggs, Matt. *Shoot the Buffalo*. Astoria: Clear Cut Press, 2005.

Carson, Anne. *Plainwater*. New York: Vintage Contemporaries, 2000.

Chave, Robert. Walter De Maria, *The Lightning Field, Chaos Theory without Tears, Gender Studies, & Mathematics*. E-mail message to Anna Chave, April 28, 2004.

Cooke, Lynne, and Michael Govan. *Dia: Beacon*. New York: Dia Art Foundation, 2003.

Cortázar, Julio. *Hopscotch*. New York: Pantheon Books, 1987.

De Maria, Walter. "On the Importance of Natural Disasters (1960)." In *Theories and Documents of Contemporary Art*, edited by Kristine Stiles and Peter Selz, 527. Berkeley: University of California Press, 1996.

———. "The Lightning Field (1980): Some Facts, Notes, Data, Information, Statistics, and Statements." In

Theories and Documents of Contemporary Art, edited by Kristine Stiles and Peter Selz, 527–530. Berkeley: University of California Press, 1996.

———. "Technical Development of *The Lightning Field* 1976–77." Dia Art Foundation.

Foster, Hal. "The Crux of Minimalism (1986/96)." In *The Return of the Real,* 35–69. Cambridge: MIT Press, 1996.

Fried, Michael. "Art and Objecthood (1967)." In *Art and Objecthood,* 148–172. Chicago: University of Chicago Press, 1998.

Genet, Jean. *Our Lady of the Flowers.* Translated by Bernard Frechtman. New York: Grove Press, 1963.

———. *Fragments of the Artwork.* Translated by Charlotte Mandell. Stanford: Stanford University Press, 2003.

Gleick, James. *Chaos.* New York: Viking Press, 1987.

Gottschalk, Earl C., Jr. "Earthshaking News from the Art World: Sculpturing the Land." *Wall Street Journal,* September 10, 1976.

Groot, Paul. "Walter De Maria, Museum Bymans-van Beuningen." *Artforum,* March 1985, 102–103.

Hayles, Katherine. *Chaos Bound: Orderly Disorder in Contemporary Literature and Science.* Ithaca: Cornell University Press, 1990.

Hess, Thomas B. "Walter De Maria, or the Emperor's New Cat Box." *New York Magazine*, October 31, 1977.

Hughes, Robert. "10 Years that Buried the Avant-Garde." *London Sunday Times Magazine*, December 30, 1979.

Johnson, Ken. "Permutations in Steel." *Art in America*, September 1989, 198–199.

Kastner, Jeffrey, ed. *Land and Environmental Art*. London: Phaidon Press, 1998.

———. "Alone in a Crowd: The Solitude of Walter De Maria's New York Earth Room and Broken Kilometer." *Afterall*, no. 2 (2000): 69–73.

Kramer, Jane. "The Man Who Is Happening Now." *New Yorker*, November 26, 1966.

Krauss, Rosalind. "Grids." *The Originality of the Avant-Garde*. Cambridge: MIT Press, 1985: 8–22.

Larson, Kay. "New Landscapes in Art." *New York Times Magazine*, May 13, 1979.

Levine, Stacey. *Frances Johnson*. Astoria: Clear Cut Press, 2005.

Lind, Ingele. "Walter De Maria, Moderna Museet." *Artnews*, Summer 1989, 188.

McCord, Richard. "The Lightning Field." *Santa Fe Recorder*, March 22, 1979.

————. "Where the Elite Meet to Critique." *Rocky Mountain Magazine*, September 1979, 17.

Merleau-Ponty, Maurice. *Phenomenology of Perception*. New York: Routledge Classics, 2004.

Meyer, Franz. *Walter De Maria*. Frankfurt am Main: Museum of Modern Art, 1991.

Meyer, James, ed. *Minimalism*. London: Phaidon Press, 2000.

Nabokov, Vladimir. *Speak, Memory*. New York: Vintage International, 1989.

Netz, Reviel. "Working with Infinity." Interview with Reviel Netz by NOVA, 2003. http://www.pbs.org/wgbh/nova/archimedes/infinity.html.

Pasternak, Boris. *Safe Conduct: An Autobiography and Other Writings*. New York: New Directions, 1958.

Ponge, Francis. *Soap*. Translated by Lane Dunlop. Stanford: Stanford University Press, 1998.

Sarduy, Severo. *Cobra and Maitreya*. Translated by Suzanne Jill Levine. Normal, Illinois: Dalkey Archive Press, 1995.

Shapiro, David. "A View of Kassel." *Artforum*, September 1977, 56–62.

Smith, Roberta. "De Maria: Elements." *Art in America*, May/June 1978, 103–105.

Sokal, Alan, and Jean Bricmont. *Fashionable Nonsense: Postmodern Intellectuals' Abuse of Science.* New York: Picador, 1998.

Stein, Gertrude. *Tender Buttons.* Mineola, NY: Dover Publications, 1997.

Tatransky, Valentin. "Walter De Maria." *Arts Magazine,* December 1977, 16–17.

Thompson, Fritz. "The Redundant Riddle in Catron County." *Albuquerque Journal Magazine, Impact,* March 27, 1979, 18–21.

Tuchman, Maurice. *A Report on the Art and Technology Program of the Los Angeles County Museum of Art 1967–1971.* Los Angeles: Los Angeles County Museum of Art, 1971.

Wakefield, Neville. "Walter De Maria, Measure and Substance." *Flash Art International,* May/June 1995, 91–94.

Wallis, Brian. "Walter De Maria's 'The Broken Kilometer.'" *Arts Magazine,* February 1980, 88–89.

Winters, Terry. "Terry Winters on *The Lightning Field*." Dia Art Foundation, New York, June 5, 2006.

Acknowledgments

This book has taken over a decade to complete and would not have been possible without the encouragement and expertise of a network of friends and teachers. Wayne Koestenbaum inspired me to think differently about writings concerning art and has become a dear friend over the years since I sheepishly visited his office at the CUNY Graduate Center to ask him to consider being my master's thesis advisor. I am deeply grateful for his support of my writing.

Kathy Koutsis, assistant program officer of the master's degree in liberal studies, was in my corner throughout the unusual program I mapped for myself while at CUNY. Thanks also go to one of Dia Art Foundation's founders, Helen Winkler, who shared her passion and stories of *The Lightning Field* with me throughout my time working at Dia, and Anna Chave, who introduced me to her mathematician brother, who guided me to resources on chaos theory.

Gratitude goes to Stephen Berens and the editors at *X-TRA*, who published an excerpt of this text early on.

Thanks as well to Ken Chen, who introduced me to Chris Fischbach, publisher of Coffee House Press. Chris, as well as Caroline Casey, managing director, and Carla Valadez, production editor, have been extraordinary in making this book real. My friend Misha Lepetic has provided invaluable advice on the manuscript.

My husband, Josh Cender, has been my most generous ally in creativity and in life. I am enormously grateful for his calm encouragement and for the world we share with our son, Giacomo.

Coffee House Press began as a small letterpress operation in 1972 and has grown into an internationally renowned non-profit publisher of literary fiction, essay, poetry, and other work that doesn't fit neatly into genre categories.

Coffee House is both a publisher and an arts organization. Through our *Books in Action* program and publications, we've become interdisciplinary collaborators and incubators for new work and audience experiences. Our vision for the future is one where a publisher is a catalyst and connector.

LITERATURE
is not the same thing as
PUBLISHING

Funder Acknowledgments

Coffee House Press is an internationally renowned independent book publisher and arts nonprofit based in Minneapolis, MN; through its literary publications and Books in Action program, Coffee House acts as a catalyst and connector—between authors and readers, ideas and resources, creativity and community, inspiration and action.

Coffee House Press books are made possible through the generous support of grants and donations from corporations, state and federal grant programs, family foundations, and the many individuals who believe in the transformational power of literature. This activity is made possible by the voters of Minnesota through a Minnesota State Arts Board Operating Support grant, thanks to the legislative appropriation from the arts and cultural heritage fund. Coffee House also receives major operating support from the Amazon Literary Partnership, the Bush Foundation, the Jerome Foundation, The McKnight Foundation, Target Foundation, and the National Endowment for the Arts (NEA). To find out more about how NEA grants impact individuals and communities, visit www.arts.gov.

Coffee House Press receives additional support from the Elmer L. & Eleanor J. Andersen Foundation; the David & Mary Anderson Family Foundation; the Buuck Family Foundation; the Carolyn Foundation; the Dorsey & Whitney Foundation; Dorsey & Whitney LLP; the Knight Foundation; the Rehael Fund of the Minneapolis Foundation; the Matching Grant Program Fund of the Minneapolis Foundation; the Schwab Charitable Fund; Schwegman, Lundberg & Woessner, P.A.; the Scott Family Foundation; the US Bank Foundation; VSA Minnesota for the Metropolitan Regional Arts Council; the Archie D. & Bertha H. Walker Foundation; and the Woessner Freeman Family Foundation in honor of Allan Kornblum.

The Publisher's Circle of Coffee House Press

Publisher's Circle members make significant contributions to Coffee House Press's annual giving campaign. Understanding that a strong financial base is necessary for the press to meet the challenges and opportunities that arise each year, this group plays a crucial part in the success of Coffee House's mission.

Recent Publisher's Circle Members Include

Many anonymous donors, Mr. & Mrs. Rand L. Alexander, Suzanne Allen, Patricia A. Beithon, Bill Berkson & Connie Lewallen, E. Thomas Binger & Rebecca Rand Fund of the Minneapolis Foundation, Robert & Gail Buuck, Claire Casey, Louise Copeland, Jane Dalrymple-Hollo, Ruth Stricker Dayton, Jennifer Kwon Dobbs & Stefan Liess, Mary Ebert & Paul Stembler, Chris Fischbach & Katie Dublinski, Kaywin Feldman & Jim Lutz, Sally French, Jocelyn Hale & Glenn Miller, the Rehael Fund-Roger Hale/Nor Hall of the Minneapolis Foundation, Randy Hartten & Ron Lotz, Jeffrey Hom, Carl & Heidi Horsch, Amy L. Hubbard & Geoffrey J. Kehoe Fund, Kenneth Kahn & Susan Dicker, Stephen & Isabel Keating, Kenneth Koch Literary Estate, Jennifer Komar & Enrique Olivarez, Allan & Cinda Kornblum, Leslie Larson Maheras, Lenfestey Family Foundation, Sarah Lutman & Rob Rudolph, the Carol & Aaron Mack Charitable Fund of the Minneapolis Foundation, George & Olga Mack, Joshua Mack, Gillian McCain, Mary & Malcolm McDermid, Sjur Midness & Briar Andresen, Maureen Millea Smith & Daniel Smith, Peter Nelson & Jennifer Swenson, Marc Porter & James Hennessy, Jeffrey Scherer, Jeffrey Sugerman & Sarah Schultz, Nan G. & Stephen C. Swid, Patricia Tilton, Stu Wilson & Melissa Barker, Warren D. Woessner & Iris C. Freeman, Margaret Wurtele, Joanne Von Blon, and Wayne P. Zink.

For more information about the Publisher's Circle and other ways to support Coffee House Press books, authors, and activities, please visit www.coffeehousepress.org/support or contact us at info@coffeehousepress.org.

At the Lightning Field was designed by
Bookmobile Design & Publisher Services.
Text is set in Goudy Old Style.